Constable.

THE LIFE AND WORKS OF

CONSTABLE

— Clarence Jones —

A Compilation of Works from the
BRIDGEMAN ART LIBRARY

PARRAGON

Constable

This edition first published in Great Britain in 1994
by Parragon Book Service Limited

© 1994 Parragon Book Service Limited

ISBN 1 85813 521 4

Printed in Italy

Designer: Robert Mathias

JOHN CONSTABLE 1776-1837

Constable.

To MANY OF HIS CONTEMPORARIES, John Constable seemed a simple copyist of nature, painting faithful renditions of the English countryside; and in his lifetime, although admired by some, he did not achieve universal recognition as an artist of stature. Even today, though he is certainly among the best-loved of English artists, he is appreciated less for the greatness of his art than for what seems to be his idyllic summing up of English country life. In fact, Constable was attempting much more – nothing less than using landscape painting as a means of conveying ideas about morality and intellectual truth.

Before Constable, landscape had been the background in paintings with historical or mythological themes. Constable brought landscape to the fore as a theme in itself. Even his own view of the role of nature in the life of man changed as he painted it. He began by looking on nature as 'the one gentle and unreproving friend', but as he painted, drew and sketched, so his viewpoint changed. Living in Hampstead made him lift his eyes from field and valley to the skies and clouds above; now nature began to seem changing and blacker, more dramatic. He began to talk of the 'chiar'oscuro of nature' and to note 'the influence of light and shadow upon landscape . . . to show its use and power as a medium of expression'. Today, we are still learning to appreciate the full effects of this quiet, unremarkable man's artistic revolution.

John Constable was born in East Bergholt, Suffolk, on 11 June 1776. He was the fourth child of Golding and Ann Constable and grew up in middle-class comfort at the centre of a large family. Golding Constable was a prosperous corn-merchant whose business activities included a shipping operation. He had inherited Flatford Mill on the Suffolk

Stour and later acquired an interest in Dedham Mill and owned a windmill at East Bergholt, where the family had a substantial mansion. All these buildings and the Suffolk countryside in which they were set were to become important subjects for the art of John Constable, so much so that the area has come to be known as 'Constable Country'.

Constable himself seemed at first destined to join his father's business and began training as a miller in 1793. Even at this time, however, he was painting in his spare time, often in company with a friend, John Dunthorne, who was a plumber, glazier and painter of inn signs. Much of their painting and drawing was done in the open air.

By the time he was 20, Constable had met several artists and art connoisseurs, discovered the glorious work of the painter Claude, and had learnt enough about art to know that it was the only course he wanted to pursue in life. It was not until 1799, however, that he won his parents over to this point of view, gaining their permission to study at the Royal Academy Schools in London.

He exhibited work at the Royal Academy exhibition for the first time in 1802, the year in which he refused a secure appointment as military drawing master at the Royal Military Academy. He was by now fully committed to the life of an artist and to a search for what he called 'natural painture', based on a whole-hearted commitment to nature and to landscape art – though the landscape art must have a serious moral and intellectual purpose: Constable was not out just to paint pretty pictures.

Landscape painting *en plein air* was not a concept unique to the young Constable, but where he differed from most of his contemporaries was in his insistence on completing as much as possible of a painting with the subject in front of him. It was not until later in life when he began painting his great 'six-footers' – large canvases intended for exhibition at the Royal Academy – that Constable kept his paintings for considerable periods of time on the easel in his Hampstead studio. Even with these paintings, much work, especially the many preliminary sketches and studies he did, was

completed out in the open air.

Unlike his contemporary and rival, J.M.W. Turner, Constable did not travel abroad, or even out of England. There was a journey from London to Deal in an East Indiaman in 1803, a trip to the Lake District in 1806, visits to friends in different parts of England – most notably to his friend the Rev. (later Archdeacon) John Fisher in Salisbury – and various sojourns with his family at English resorts, including Brighton and Hove. Apart from these, Constable divided his time between London and Suffolk.

The English countryside was his great inspiration. From it, he drew such masterpieces as *The Haywain,* exhibited at the Royal Academy, View on the Stour at Dedham, exhibited in 1822, and *The Leaping Horse.* The first two were shown at the Paris Salon in 1824, the year in which Charles x of France awarded him a Gold Medal. Probably of greater significance to Constable was his election as a Royal Academician in 1829, even though it came just months after the death of his beloved wife Maria.

Constable had met Maria Bicknell at his home village in 1809. She was staying in East Bergholt with her grandfather, Dr Durand Rhudde, and the two were soon in love. But Dr Rhudde disapproved of the connection because he did not believe that John Constable was ever likely to earn a reasonable living as an artist. The couple had to wait until the death of Constable's mother, followed by that of his father, provided him with a legacy and an assured income. They were married in London in 1816.

From now on his family and his art were the twin poles of Constable's life. The death of Maria Constable from tuberculosis in 1828, after seven pregnancies in 12 years of marriage, is said to have devastated Constable. Critics have noted a certain loneliness and a less gently evocative approach to nature in his later paintings, along with a harking back to earlier work in many of them.

He was still working hard, still evolving new theories on landscape painting when he died, probably of a heart attack, in March 1837. He was buried at Hampstead Parish Church.

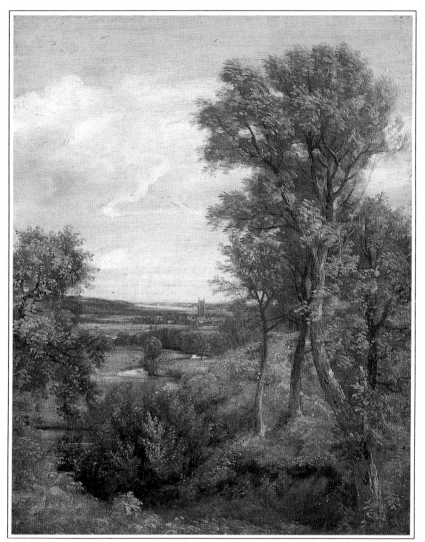

◁ **Dedham Vale** 1802

Oil on canvas

THIS IS THE FIRST oil painting Constable did of Dedham Vale, which became the most familiar of all his landscape themes. The view is taken from Gun Hill, Langham, looking down on the valley of the Stour. It was Constable's first painting to be accepted by the Royal Academy, an event which may have strengthened his resolve to devote himself to painting. He had already turned down a teaching job at the Military Academy at Great Marlow because it might interfere with his desire to become a 'natural painture' and he had taken to heart Sir Joshua Reynolds's remark that there was no easy way to become a good painter. Constable knew it would be a question of total dedication.

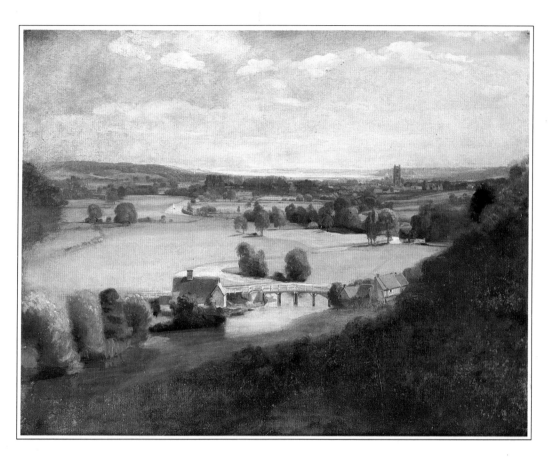

△ **The Valley of the Stour** 1805

Oil on paper laid on canvas

THE STOUR, the river that flows through the countryside that Constable made his own, appears in many of the paintings he made around Dedham in Suffolk. The square tower of the church at Dedham became a landmark in many of them, included both as a gauge of distance and as a symbol of the country life of which the church was a social centre. Constable loved the valley which was his home, seeing it as a microcosm of the whole world. 'I should paint my own places best,' he said. 'Painting is but another word for feeling. I associate my careless boyhood to all that lies on the banks of the Stour.'

▽ **Willy Lott's House** 1805

Oil on canvas

WILLY LOTT'S HOUSE at Flatford Mill became a familiar feature in many of Constable's paintings, recognizable even when he occasionally altered its shape to suit his composition. Its owner was a Suffolk farmer who saw little reason to leave his native valley and in all his 80 years never left it for more than four days. The house was at the point where a small hand-propelled ferry took people across the stream, and Constable is thought to have made his first sketch of it in 1802.

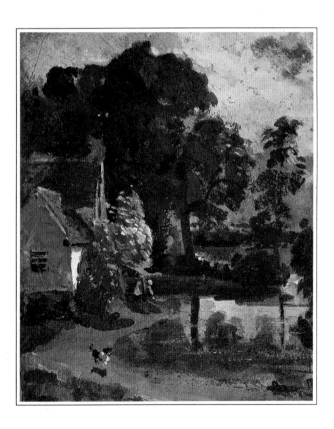

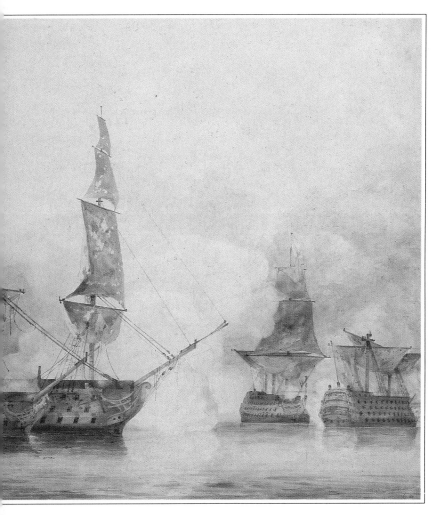

◁ **His Majesty's Ship *Victory*, Capt. E. Harvey, in the Memorable Battle of Trafalgar, between two French Ships of the Line** 1806

Watercolour

THE BATTLE OF TRAFALGAR and the defeat of French seapower stirred all England, and anyone who had been in the action was guaranteed an audience and many free pints of beer, no doubt. Constable's brother Abram recounted that the painter had been inspired to paint the great naval battle after listening to an account of the action from a Suffolk man who had been on Nelson's flagship. Constable had already sketched the *Victory* at Chatham and he was therefore able to produce a painting and exhibit it at the Royal Academy before his rival, Turner, who had to make a journey to Chatham after the *Victory* returned to England in December 1805 and was not able to exhibit his painting until later in 1806, in his own gallery.

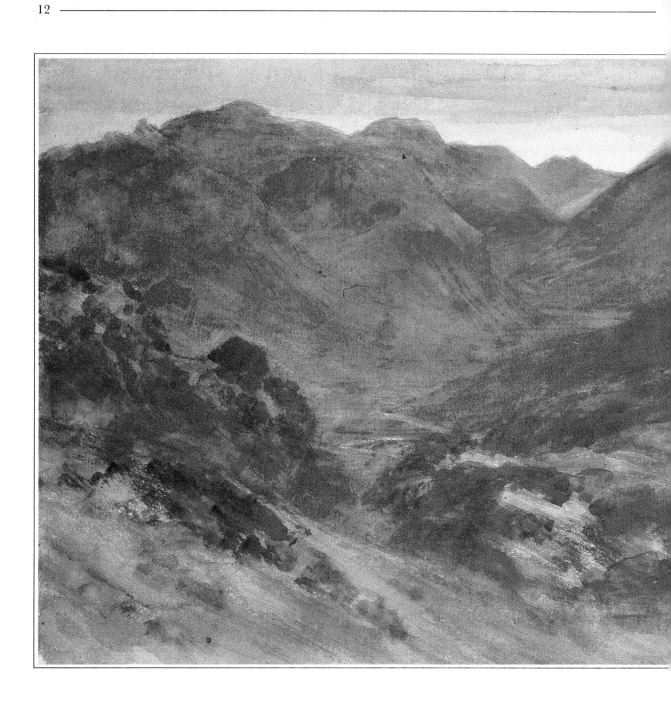

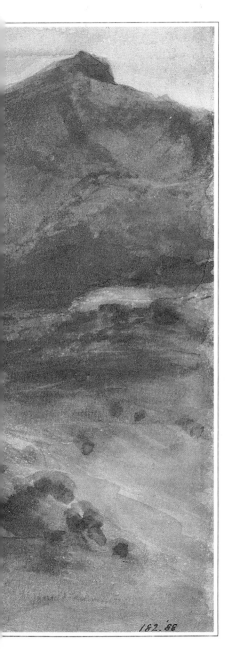

◁ **View of Borrowdale** 1806

Pencil and watercolour

CONSTABLE MADE A TOUR of the Lake District in 1806, visiting Ambleside, Lake Windermere, Borrowdale and Langdale. The English Lakes were rarely visited before the Romantics popularized the mountainous scenery with its crags, chasms and waterfalls. Until then, most people regarded them as gloomy, unfriendly places. The romantic passion for picturesque scenery changed this attitude, nature becoming almost synonymous with God. Constable, who had a deep feeling for the countryside, was inspired to produce many fine works by the mountains and clouds of the lakes, especially around the valley of Borrowdale. Though he made many watercolours and sketches, Constable did not paint any large canvases like those which he devoted to subjects in the Stour valley.

Derwentwater, Cumbria 1806

Watercolour

▷ *Overleaf pages 14-15*

THIS PAINTING SHOWS the view from the southern end of Derwentwater looking up Borrowdale towards the fells and mountains around Glaramara and Great Gable. It is just one of a great many pictures, mostly watercolours, which Constable did during a visit to the Lake District in 1806 which lasted several weeks. Current interest in the lakes suggested that Constable would find a ready market for Lake District views and, indeed, the first newspaper notices of Constable's work centred on his pictures of the lakes. 'The artist seems to pay great attention to nature . . .' noted one critic. Constable was very much a pioneer in his naturalistic approach to painting from nature.

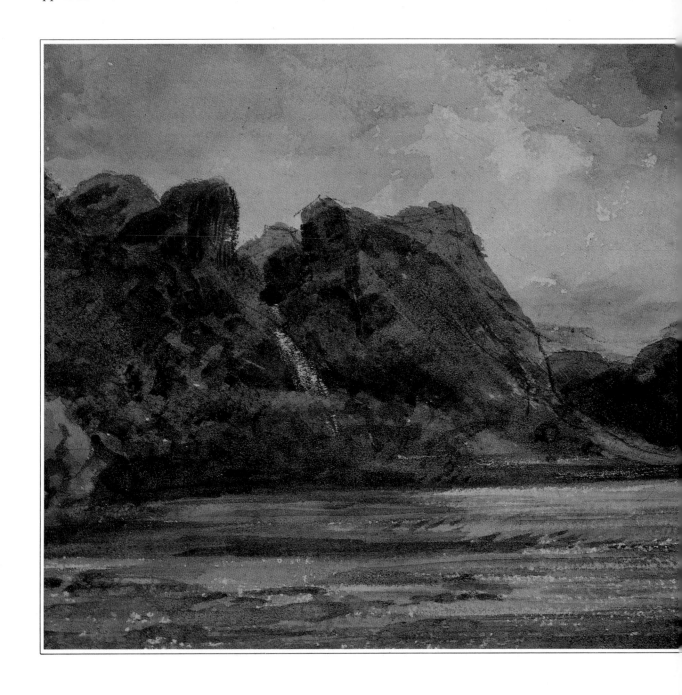

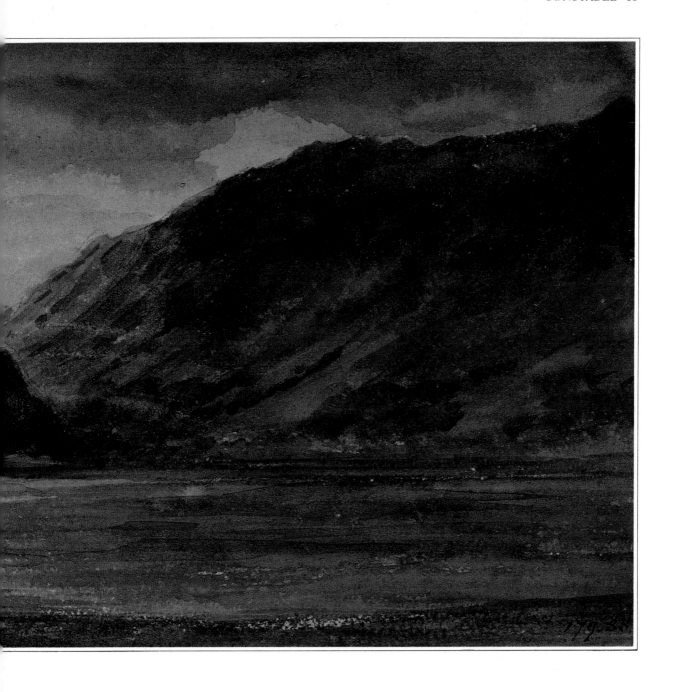

▽ **Flatford Mill from a Lock on the Stour** 1810

Oil on canvas

CONSTABLE MADE SEVERAL oil sketches of Flatford Mill, all of which aroused the admiration of his family and friends, though they were not finished enough for exhibition purposes. Though these sketches look like the work of the later Impressionists, they were painted with quite different ends in view. Constable was interested, not in theoretical ideas about colour, but in identifying with nature in an almost pagan way, as his later paintings with their earthy feeling clearly reveal.

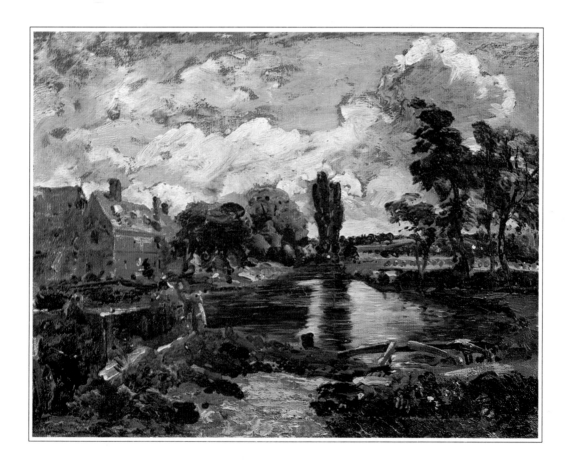

▽ **Barges on the Stour** 1811

Oil on paper

THE BARGES IN THE picture are at Flatford lock; Dedham church can be seen to the left of the faint row of poplars (which Constable omitted from a later version of the scene). At the start of his life as a painter Constable rarely altered the scenes before him; later on in life he became more relaxed about changing the scenery to suit his compositions. Many of Constable's oil sketches were done on paper and later glued on to board; this one was on brown paper, which provided a warm foundation for colder colours laid over it.

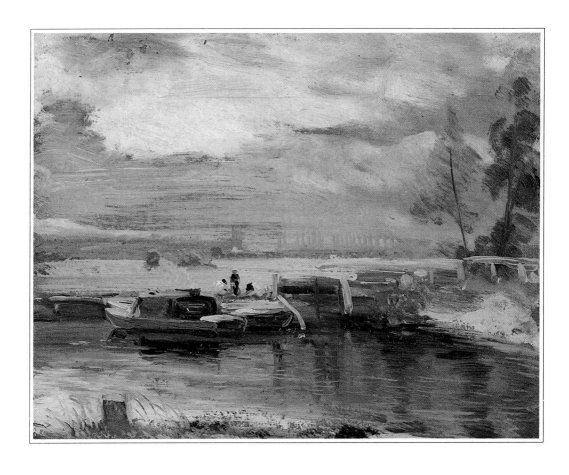

▷ **Salisbury Cathedral from the South West** 1811

Oil on paper

THIS ROUGH OIL SKETCH is in
a different category from the
well-known very finished
view of the cathedral painted
from the Bishop's Grounds,
which was exhibited at the
Academy in 1823.
Constable's large finished
paintings were done to
please popular taste, which
demanded highly finished,
glossy work; the artist himself
felt that the life of the subject
was often more real in the
sketches which he made in
direct contact with nature or,
at least, with a fresh memory
of it in his mind. It was an
approach to paintings which
the Impressionists later in
the 19th century supported
enthusiastically.

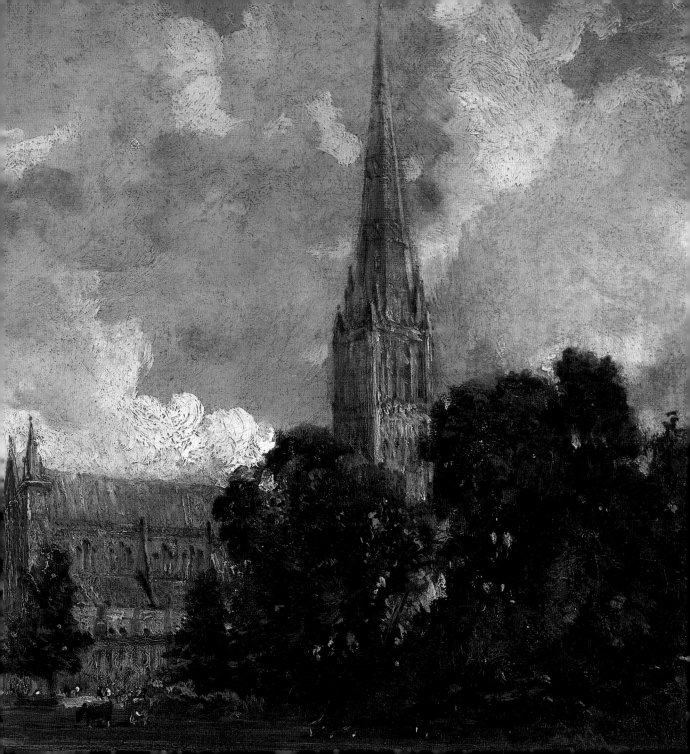

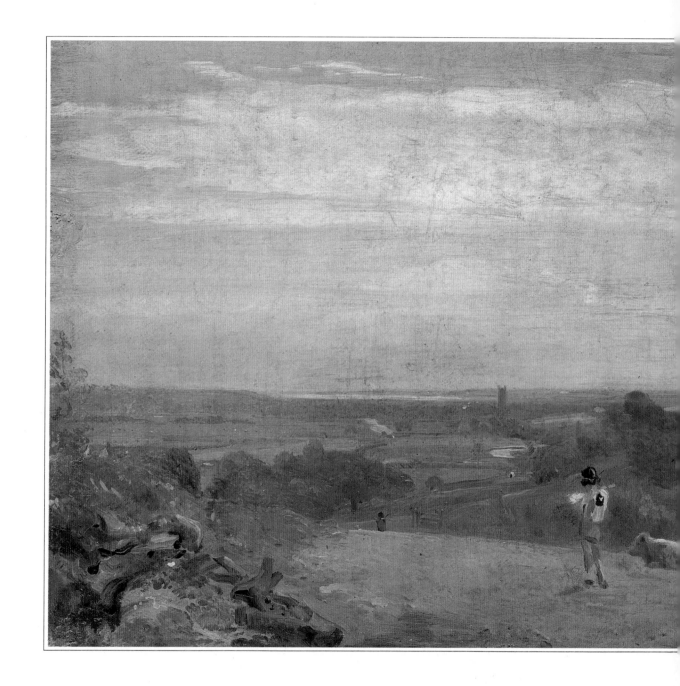

◁ **Summer Morning, Dedham – from Langham** 1812

Oil on paper

THE VIEW FROM GUN HILL or Langham was Constable's Easter viewpoint of the Stour valley, with Dedham and its church tower standing out like a lighthouse. For Constable, this little valley, with its gentle slopes and green fields and trees, was the quintessence of the English countryside. Like the Brontë sisters, Constable created a whole world in microcosm by patient observation and understanding. For the painter, Dedham Vale told the whole story of man and his relationship with nature.

▽ **The Mill Stream** c.1814

Oil on paper

THE MILL STREAM and Willy Lott's cottage became familiar features in Constable's world. The artist would sit by the mill to paint the scene, the sound of the swirling water from the mill race, which can be seen in the foreground, in his ears. There was a ferry across the stream at this point and a channel which joined the stream to the main river Stour. The most famous depiction of this scene is in Constable's *Haywain*.

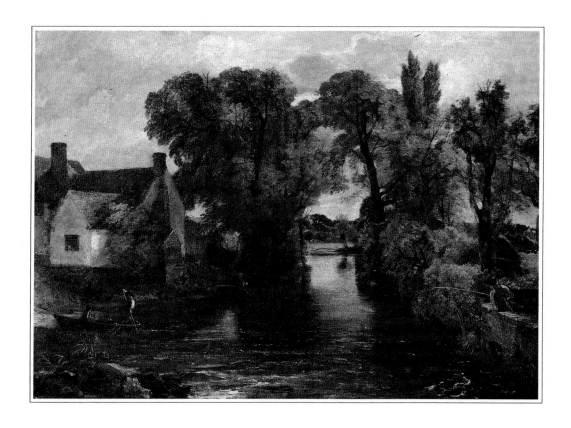

▽ **Wooded Landscape with Ploughman** 1814

Oil on paper

THIS VIEW of the Vale of Dedham was done from outside the grounds of the Old Hall, East Bergholt, looking across to Langham. The original version was bought by Constable's patron Allnutt who, finding that he did not like the sky, had it repainted by another artist. Later, he asked Constable to restore it to its former appearance. With great forbearance, Constable offered to do another painting. The ploughman in the scene was an afterthought: Constable had painted an empty landscape but, thinking it too bleak, he touched up the colour with a warmer shade and added the ploughman.

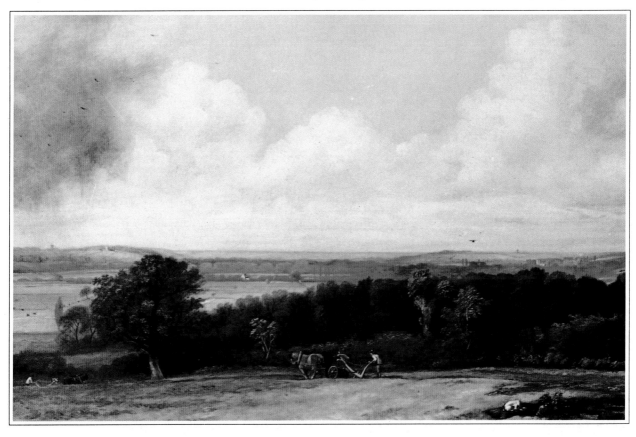

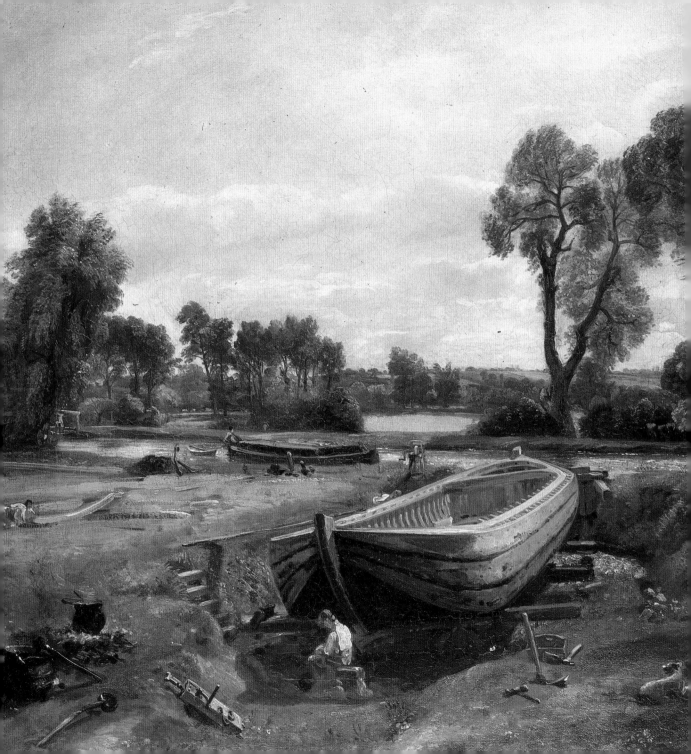

◁ **Boatbuilding** 1814

Oil on paper

THE BOATBUILDING YARD near Flatford Mill belonged to Constable's father. There, the horse-drawn barges, which took the mill's products down to the Stour estuary for shipping to the markets, were built and repaired. Much of this and similar paintings was done in the open air at the yard, though bad weather often made it necessary to finish the work in the studio. Constable usually made quick sketches in wash or pencil to capture the atmosphere and general composition of a scene, then started a new painting later in his studio. He adhered to the actual appearance of the scenes, unlike Turner who took considerable liberties with reality.

▽ **A Lock on the Stour** 1815

Oil on canvas

THIS LOCK AND TOWPATH was perhaps at Flatford and is similar to the setting of Constable's *Landscape: Boys Fishing,* painted in 1813. The handling of the paint is lively and the atmosphere full of the 'feeling' that Constable considered so important in the rendering of landscapes. The 'sentiment of nature', as he called it, was an essential ingredient in Constable's work and the one which sets him apart from painters of nature before him and the Impressionists who followed him.

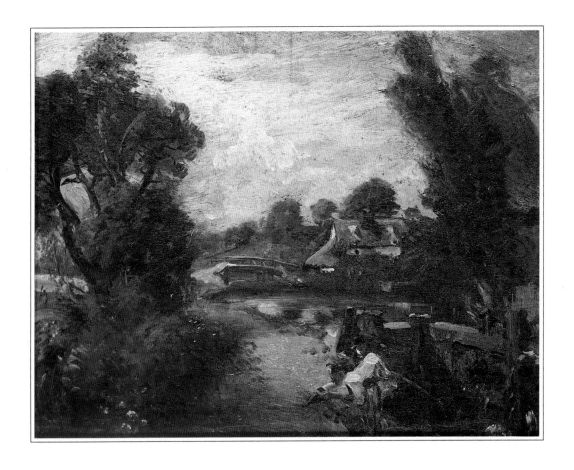

▷ **The Valley Farm** 1815

Oil on canvas

ANOTHER PEACEFUL SCENE painted in the fateful year of Napoleon's defeat at Waterloo shows Constable's increasing power as a painter of rural scenes. The building in the picture is none other than Willy Lott's cottage, seen from an unusual angle. Constable started sketching this scene in 1800 and did several paintings, presenting a final version at the Royal Academy in 1835. Though he spent a great deal of time on The Valley Farm, Constable was not satisfied with it and wrote to a friend, 'My picture must go but it is woefully deficient in places.' At least one critic agreed with him, calling it 'poorest in composition, beggarly in parts, miserably painted and without the least truth in colour'.

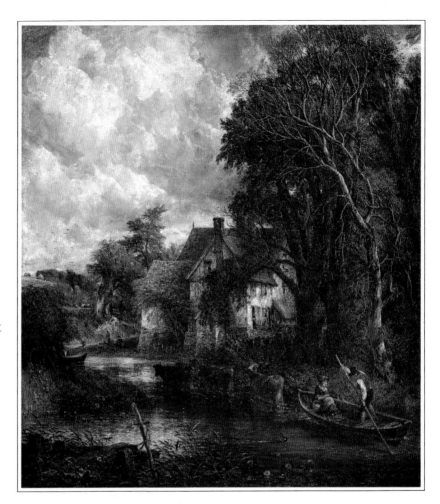

▷ **Golding Constable's Kitchen Garden** 1815

Oil on canvas

CONSTABLE'S TALENT for making the most ordinary scene into a magical landscape is well illustrated in the views he sketched and painted from his father's house. This one from the back of the house looks over his father's kitchen garden, a subject that most painters of the time would have ignored, across to the open countryside, thus combining the idea of nature and man's partnership with it in agriculture. Painting it also enabled Constable to look across to East Bergholt rectory (in the centre of the picture), where his beloved Maria often stayed when she visited the village. The two were married in the year after this painting was executed.

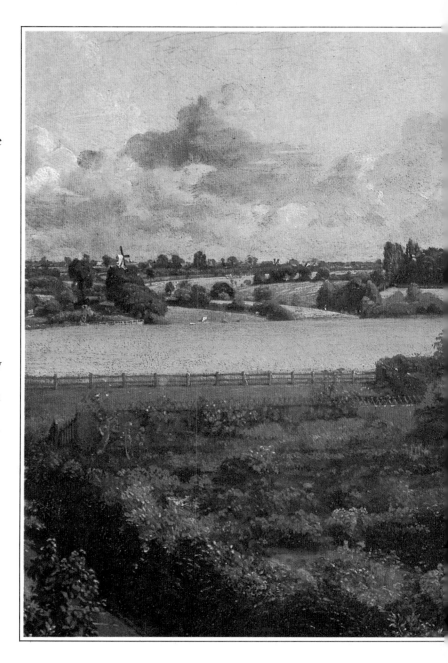

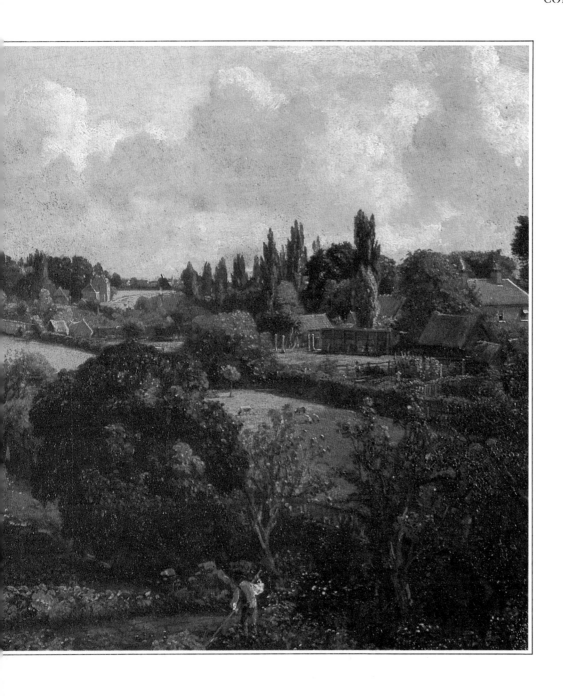

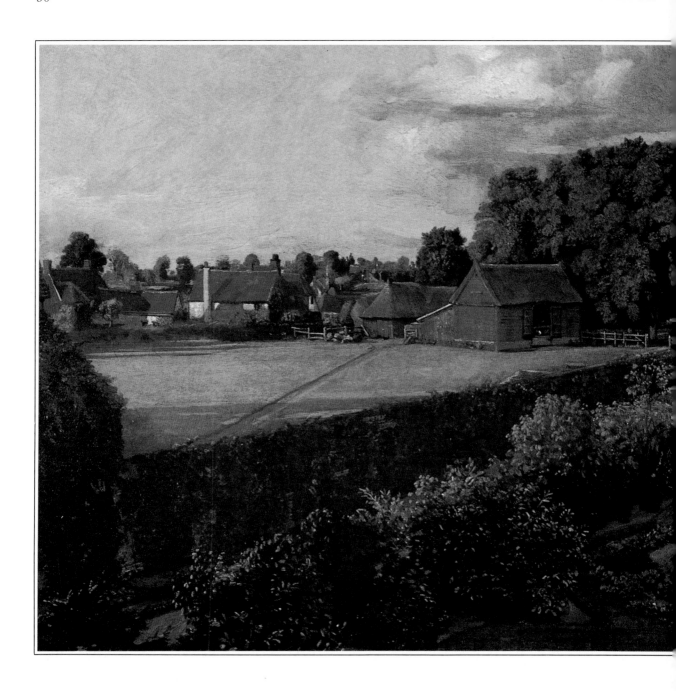

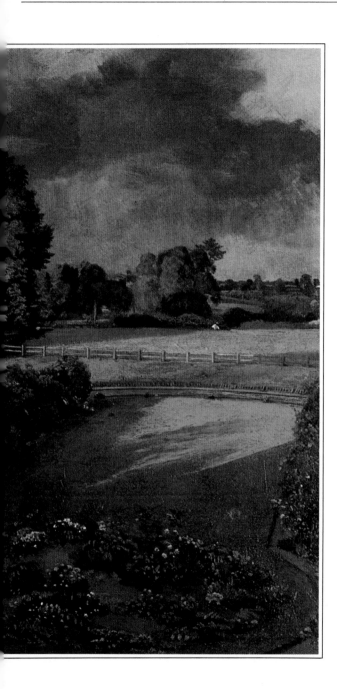

◁ **Golding Constable's Flower Garden** 1815

Oil on canvas

THIS COMPANION PIECE to *Golding Constable's Kitchen Garden* was also painted from an upstairs window at the back of the family house in East Bergholt. Constable has painted the neatly planted flower garden exactly as it was, in accordance with his ideas about absolute visual truth, a rather narrow view which he was later to abandon. The two paintings are among the most important of his early work, their extraordinary detail giving a near-idyllic view of the English country scene at the close of the Napoleonic Wars.

▽ **Maria Bicknell** 1816

Oil on canvas

CONSTABLE'S COURTSHIP of Maria Bicknell was a long-drawn-out affair, his apparent inability to earn a living through his painting causing her maternal grandfather, Dr Durand Rhudde, rector of East Bergholt, to oppose their marriage. The good rector did not believe that Maria, who had been brought up in a comfortable home, could put up with the difficulties of an impecunious artist's life. In the end, true love triumphed, though not until Constable's mother had died and he inherited an allowance of £300 and profits from the family business. The couple were married on 2 October 1816 at St Martin-in-the-Fields Church in Trafalgar Square, London.

▷ **Ann & Mary Constable** 1816

Oil on canvas

THE LADY ON THE LEFT is Constable's eldest sister Ann (1768-1854) and the other his sister Mary (1781-1862). Neither girl married and when their father died they each moved into new homes, Ann to 'Wheelers' a house at Bergholt, and Mary to her younger brother Abram's home at Flatford Mill. Constable's portraits of the girls show two quite different characters, with Ann looking rather stern and masculine and Mary frail and feminine.

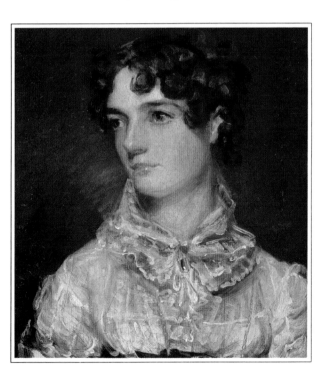

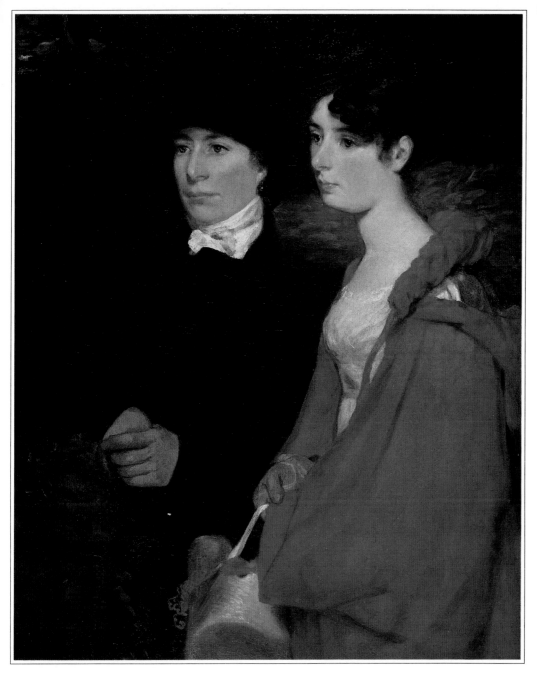

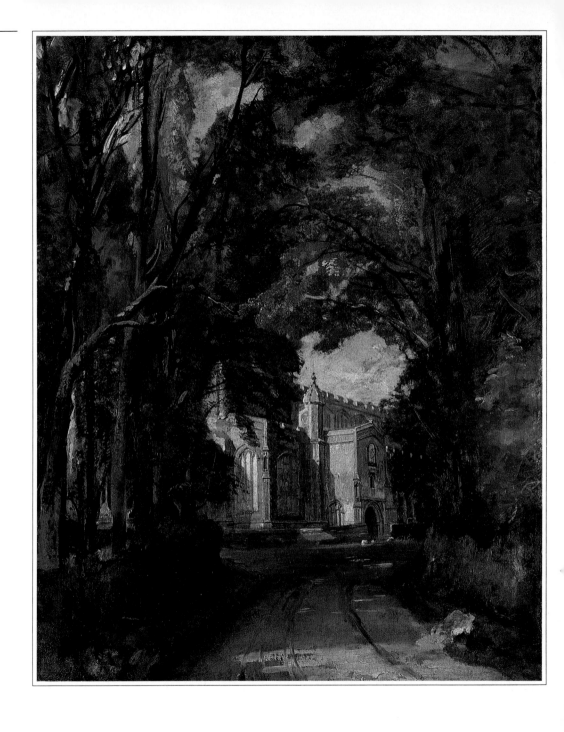

◁ **East Bergholt Church through Trees** 1817

Oil on paper

CONSTABLE'S FATHER, Golding Constable, built a large house at East Bergholt two years before his eldest son was born. The family grew in the way that was usual in 19th-century England; and as Golding Constable was a reasonably successful businessman they lived well. There were six children – three boys and three girls – and they naturally all attended the local church where Dr Durand Rhudde, maternal grandfather of Maria Bicknell, was the rector. Since the church had a prominent place in Constable's life, it is not surprising that he painted it several times.

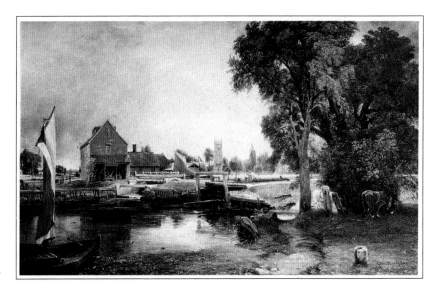

△ **Dedham Lock and Mill** c.1819

Oil on canvas

DEDHAM MILL WAS OWNED and operated by Constable's father, Golding Constable. From here he exported flour by barges which returned loaded with other merchandise which he sold to increase the profits of the business. This is one of Constable's early paintings of the mill and shows a certain stiffness in the handling of the paint in some areas, especially on the trees on the right.

In another version, Constable added a horse and a boat in the foreground, which suggests that he was not entirely happy with the composition. Dedham Mill seems to have been among Constable's popular subjects, for he did several versions of it, at least one of which was apparently exhibited at the Royal Academy in 1818.

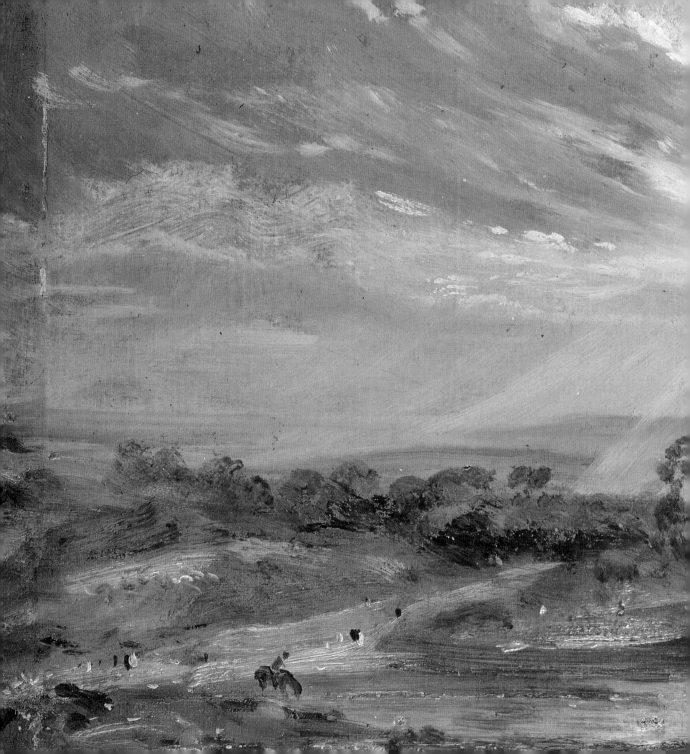

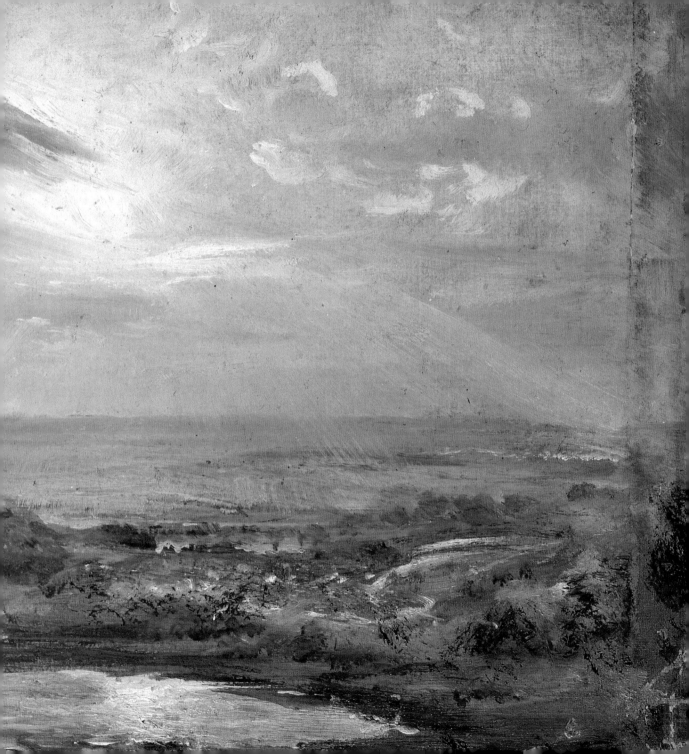

▷ **The Admiral's House** 1820-5

Oil on canvas and board

THE ADMIRAL'S HOUSE, which appears in several of Constable's paintings, was a well-known Hampstead landmark, lived in by Admiral Matthew Barton (died 1795) who had served in the Royal Navy. The Admiral, reputed to be an eccentric fellow, had turned the roof of his house into a quarterdeck complete with cannon. The house, which stood like a tower amid the wild natural landscape, appealed to Constable, who made the most of its rural setting.

Branch Hill Pond 1819

Oil on canvas

◁ *Previous pages 36-37*

IN CONSTABLE'S TIME the heights of Hampstead provided an uninterrupted view of countryside to the west over Branch Hill and its ponds. Even Windsor Castle was clearly visible, as one can see from its appearance on the right-hand side of this painting. Apparently, the view attracted much attention for there were several would-be buyers, among them a Mr Darby, son of the builder of Iron Bridge, who paid £130 for it. Constable made a copy of the picture which he sold to a customer in Paris.

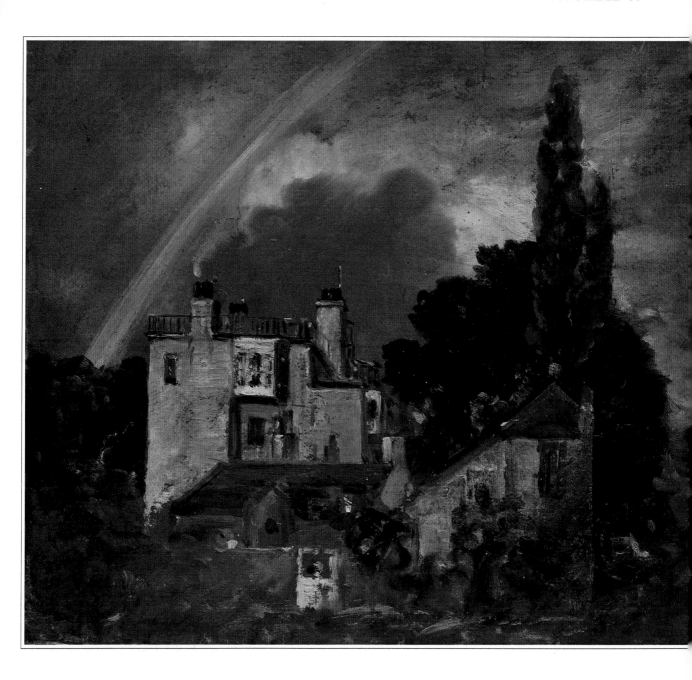

▷ **Judges Walk, Hampstead** c.1820-7

CONSTABLE'S FIRST FEW YEARS in London with his wife Maria were, he wrote to his friend Fisher, 'the happiest years of my life'. At first Constable and Maria lived in the centre of town in Keppel Street and then in Charlotte Street. In 1819, having started a family which soon grew to seven, Constable bought a house in Hampstead where he could live in more rural surroundings and work in peace on paintings of Hampstead, its heath and woods.

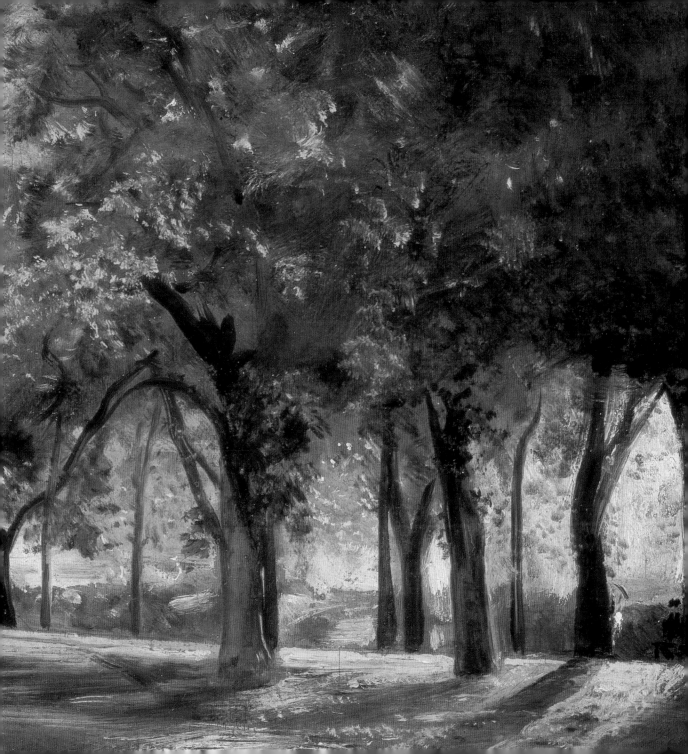

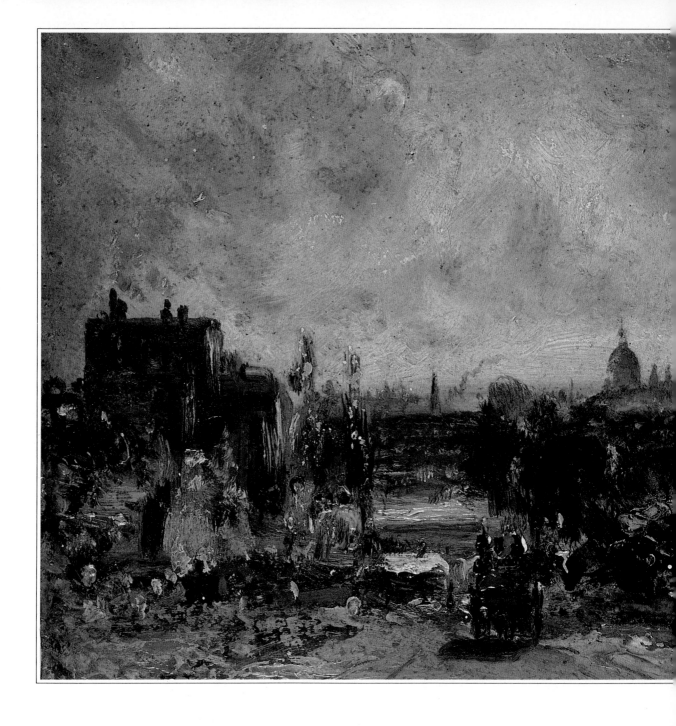

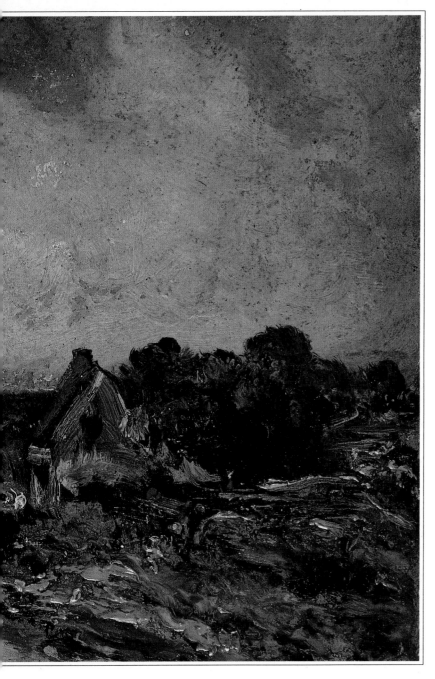

◁ **The City of London from Sir Richard Steele's Cottage, with the Mail Coach on the Road** c.1820-5

Oil on paper

THE CONSTABLES MOVED to Hampstead partly for the sake of Maria Constable's health. That the artist himself was happy there is evident from the many fine paintings which can be dated from the Hampstead years, including this one, painted near the north London house of the 18th-century essayist, Sir Richard Steele. The oil sketch shows the great freedom with which Constable was handling paint during his Hampstead period – a freedom which, after his death, would liberate painting in England towards the end of the century.

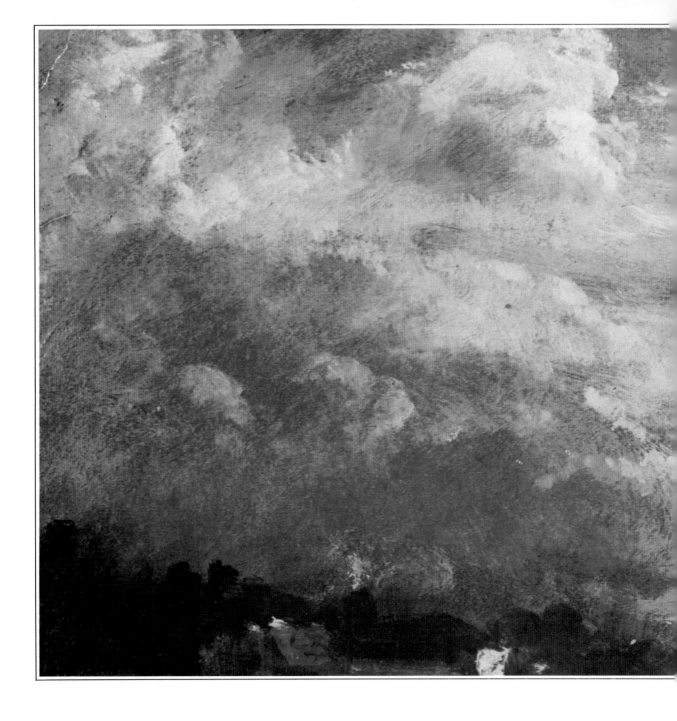

◁ **Cloud Study, Horizon of Trees** c.1821-8

Oil on paper

WHILE LIVING IN HAMPSTEAD Constable devoted much of his time to making studies of clouds from his splendid viewpoint on the Hampstead hills. From here he was able to study the clouds in every direction – coming in over the countryside of the Thames valley or sweeping over London from the east. He may well have been prompted to this study of clouds by a criticism of the sky in his *Flatford Mill* painting, which some had thought not to have looked part of the composition. Writing to his friend the Rev. John Fisher, Constable said, 'I have done a good deal of skying – I am determined to conquer all difficulties and that most arduous one among the rest.'

▷ **The Haywain** 1821

Oil on canvas

CONSTABLE'S MOST FAMOUS painting took him less time to finish than most of his large compositions, though he made many sketches for it before deciding on the final composition. The picture was painted at the suggestion of his friend Joseph Farington R.A., who had thought that Constable should paint another picture in the style of his earlier painting of Stratford Mill, which had been a success at the Academy and with the public. Constable had been trying to complete a large painting of the opening of Waterloo Bridge by the Prince Regent in 1817, but he now put this aside to concentrate on *The Haywain*. The finished painting was shown at the Royal Academy, where it was titled *Landscape – Noon,* although Constable and his friends referred to it as 'The Haywain'. It did not sell and was eventually sent for exhibition at the Paris Salon, where the painter Gericault was much impressed by it, as was King Charles X, who presented Constable with a Gold Medal.

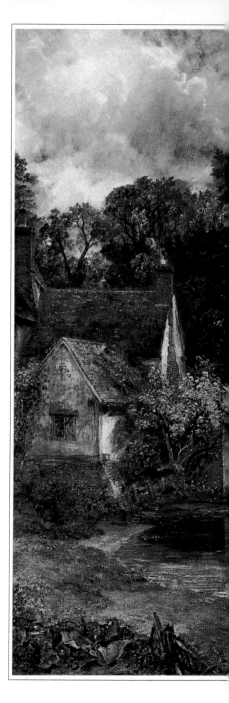

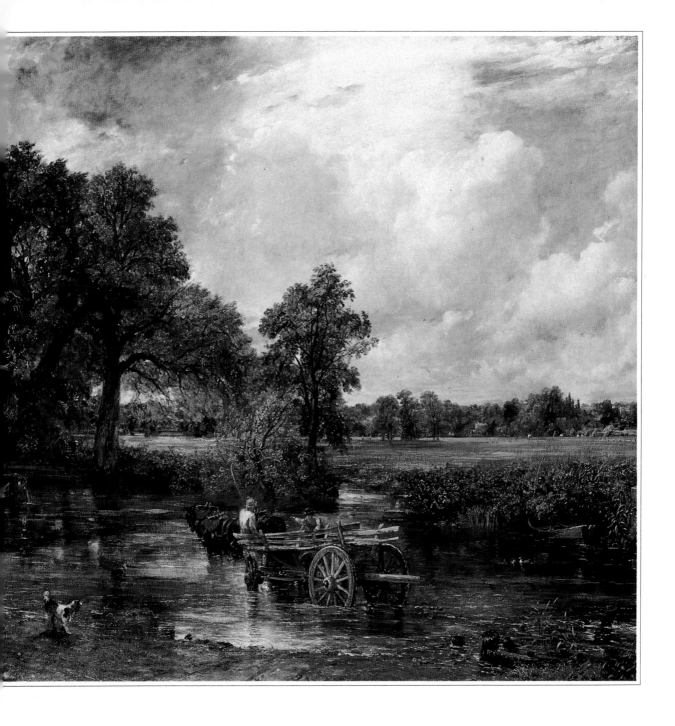

▽ **A View of the Stour, near Dedham** 1822

Oil on paper

THE FINISHED VERSION of this painting was exhibited in 1822 and was bought by John Arrowsmith, a Paris dealer, who exhibited it in the French capital with THE HAYWAIN in 1824. Both paintings were much admired, especially by Delacroix, and helped to establish Constable's name abroad. The scene is a familiar one: the view from Flatford Mill looking towards Dedham. Constable worked a long time on this painting, altering it several times and wrote to John Fisher that, 'I never worked so hard before . . . but still I hope the work in it is better than any I have done yet.'

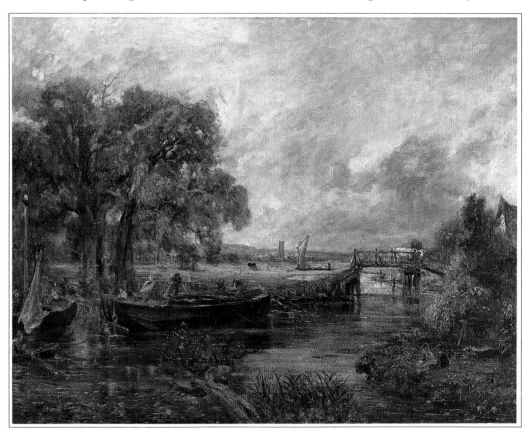

▽ Salisbury Cathedral, from the Bishop's Grounds 1823

Oil on canvas

IN 1811 CONSTABLE had become close friends with John Fisher, nephew of the Bishop of Ipswich, who later became Bishop of Salisbury. The Bishop commissioned this, the most finished, of Constable's paintings of the cathedral, after having seen some of Constable's sketches. Perhaps in gratitude for the commission, Constable included the Bishop and his wife on the left-hand side of the painting. The Bishop was sufficiently pleased to order another, smaller copy and also bought Constable's *White Horse* painting. Unfortunately, as a result of running into money difficulties, the Bishop had to sell two of the paintings back to the artist.

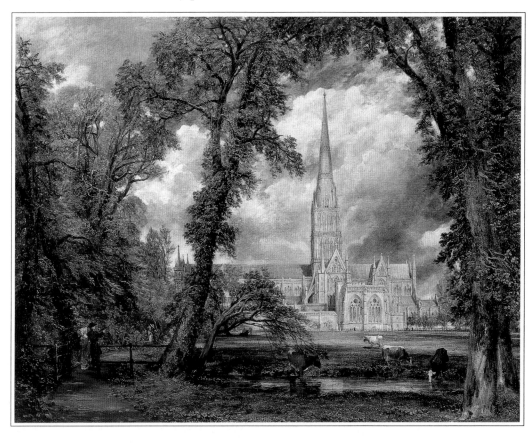

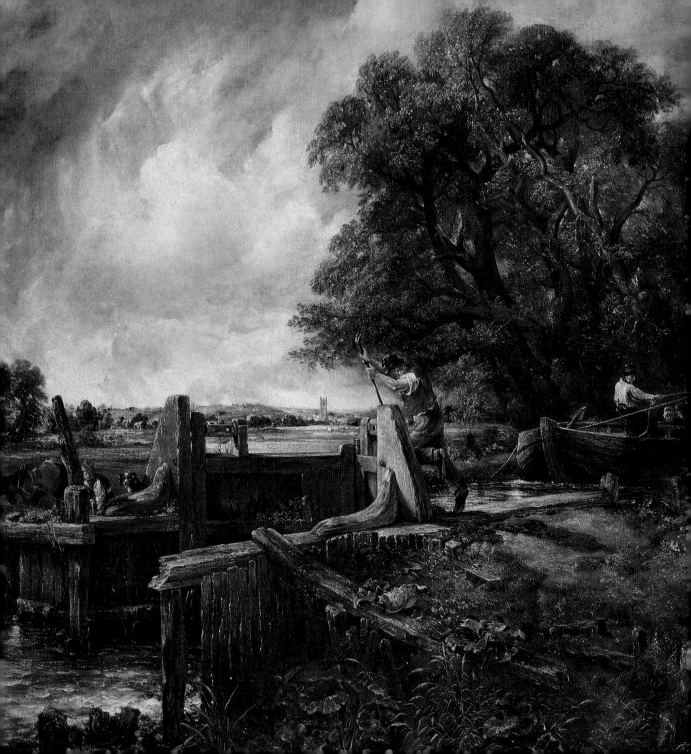

◁ **A Boat Passing a Lock** 1824

Oil on canvas

THIS LOCK IN THE STOUR valley is almost certainly at Flatford Mill, for Dedham church tower can be seen in the distance. Locks were made of wood and the sluices was opened by inserting a crowbar to move the rollers, which is what the man in Constable's picture is doing. This painting marks an important change in Constable's work. There is an earthiness about it, especially in the foreground, which became characteristic of Constable's later work and which he achieved by a rougher handling of the paint, including the use of a palette knife.

▽ **Hove Beach** c.1824-7

Oil on paper

THE BEACHES OF THE SOUTH coast of England gave Constable the opportunity to study the effects of clouds over water which would be different from those he had been sketching at Hampstead. At Hove, Constable could get away from the artificiality of Brighton and paint on the beach undisturbed except for the occasional passer-by. Here, he has depicted a sea made choppy by the wind and has included ships offshore.

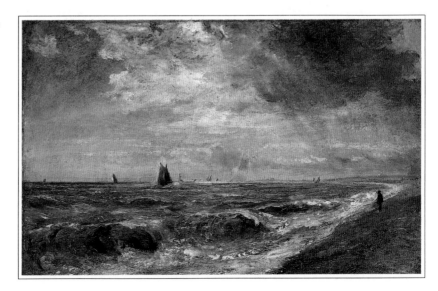

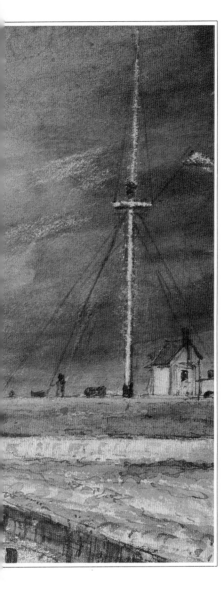

◁ **Littlehampton** c.1824-7

Oil on paper

THE LONELY WINDMILLS on the beach at Littlehampton, a small south coast village near Brighton, may have reminded Constable of the Suffolk windmills. He was in Brighton hoping that it would improve the health of his wife, who had been unwell after the birth of her sixth child. She was destined to die in 1828 soon after their Brighton sojourn, leaving him desolate. 'Hourly do I feel the loss of my departed angel,' he wrote to his brother Abram. 'God only knows how the children will be brought up.' The following year he was made a full member of the Royal Academy.

Brighton Beach c.1824-6

Oil on paper

▷ *Overleaf pages 54-55*

THIS BRIGHTON BEACH painting is probably a study for the seashore that appears in the only complete painting Constable made of Brighton. Like his other Brighton and Hove studies and the paintings he had made earlier in Yarmouth, Constable's seascapes are empty and the seas are calm. The whole picture area is used simply as a space in which to create a composition in which sea and sky come together as a harmonious whole. Constable often did oil sketches such as this one on paper, later gluing them on to board.

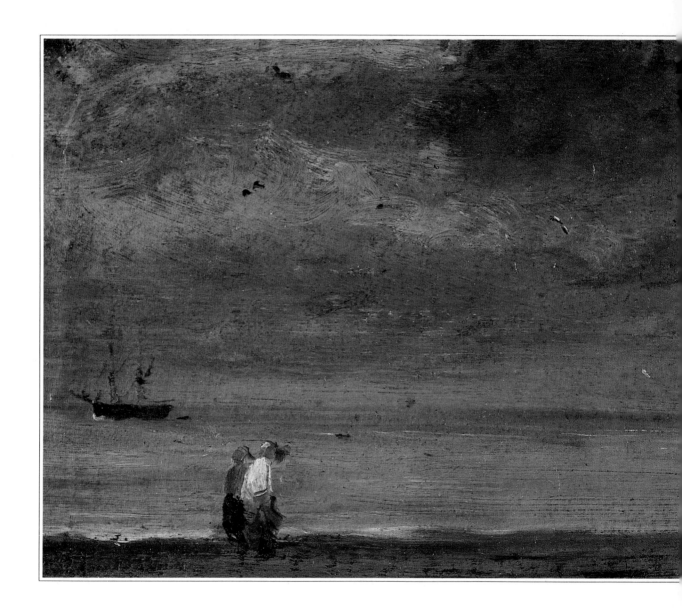

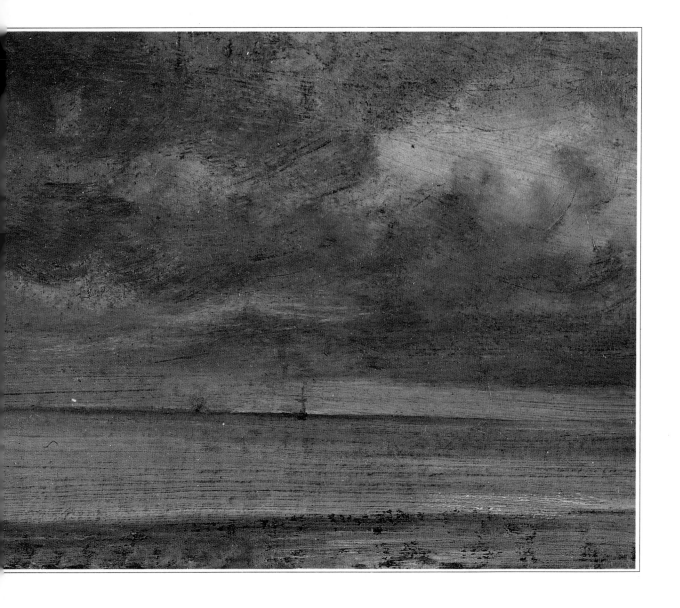

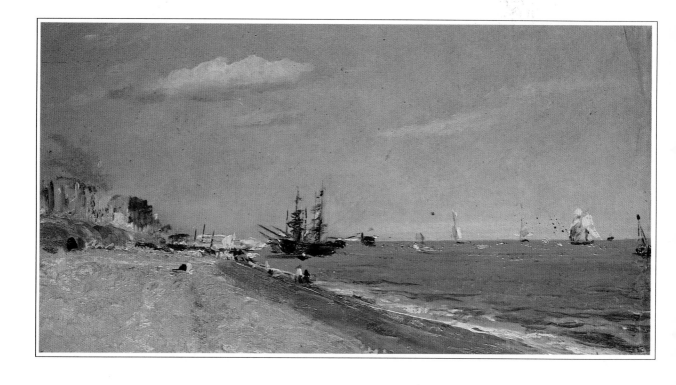

△ **Brighton Beach with Colliers** 1824

Oil on paper

THIS IS ONE OF Constable's finest Brighton pictures, apparently done from nature, for it has a great freshness. According to a note on the back, it was done from the head of the Chain Pier beach one evening in July. Most of Constable's Brighton paintings were sketches which he never developed as finished pictures.

He sent a batch of them to his friend John Fisher with the comment that the paintings 'were done in the lid of my box on my knees as usual'. Fisher sent him in return two volumes of sermons which, he said, were 'like your paintings, full of vigour, and nature, fresh, original warm from observation of nature.'

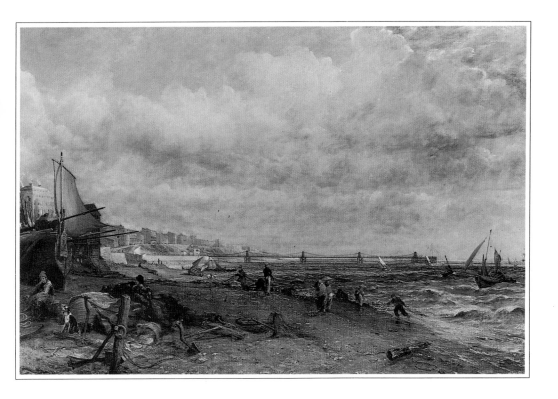

△ **Chain Pier, Brighton** 1827

Oil on canvas

CONSTABLE HAD SOME DOUBTS about painting Brighton, both as a subject and on moral grounds, for he found the seaside resort very artificial and the very antithesis of his ideals of natural beauty. However, since he was there, having taken his family there for the sake of his wife's health, he did not waste his time but made many sketches and completed two paintings. 'The magnificence of the sea,' he wrote to his friend John Fisher, 'and its (to use your own beautiful expression) everlasting voice, is drowned by the din and lost in the tumult of stage-coaches-gigs-flys and co.- and the beach is only Piccadilly by the seaside.' The finished picture was much admired at the Royal Academy, but no one was interested in buying and it remained in the artist's studio.

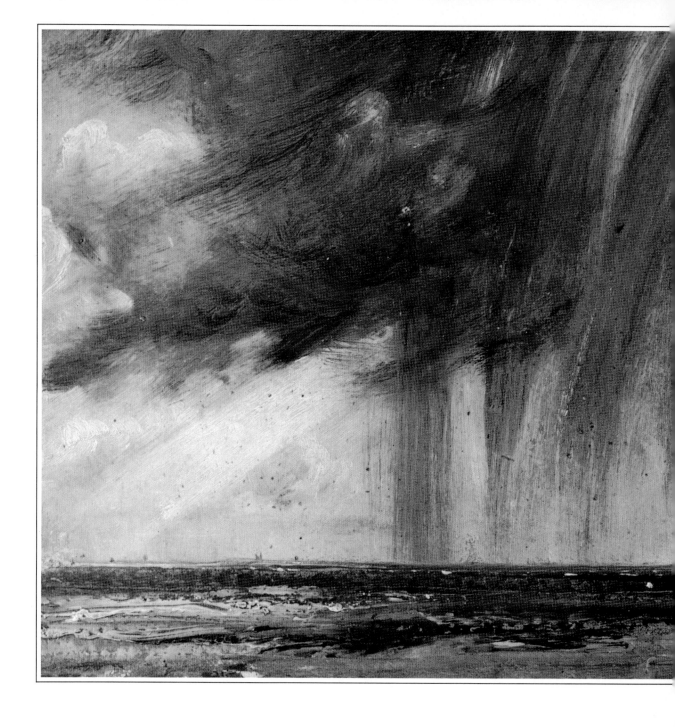

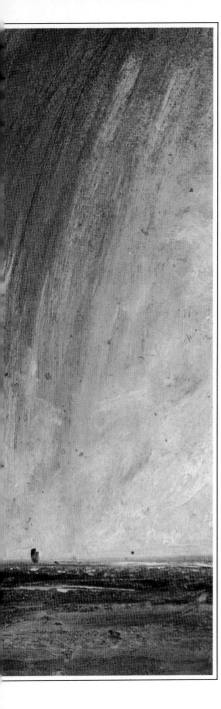

◁ **Seascape Study** 1824-7

Oil on paper

CONSTABLE LOOKED on nature with a calm and tranquil mind, seeing in its works a vast and serene progress rather than a series of dramatic events. Unlike Turner, who used nature for his own purposes to make a dramatic statement or express a philosophical view, Constable depicted nature as it appeared to him. In this painting he has caught a cloudburst over the sea with a touch of Turneresque violence, but Constable's downpour is transitory and does not turn the world upside-down.

▷ The Leaping Horse 1824-5

Oil on canvas

THIS WAS CONSTABLE'S major exhibition work of 1825 and was one of an ambitious series of six-foot paintings of the Stour valley upon which he had embarked some time before. Constable made a number of studies, including a full-size oil sketch for this great painting which sums up so many of his feelings and aims in painting. There is the earthy feeling of the foreground, the carefully delineated river plants and timbers holding up the bridge, and the sense of union of man and nature in the working bargemen in the carefully composed scene. Although the picture was well received at the Royal Academy, it was not sold, and Constable took the picture back to his studio for more alterations. In the final version, the willow stump was moved from the right side of the horse to the left, and more white accenting was added to balance the picture and give it a greater sense of movement.

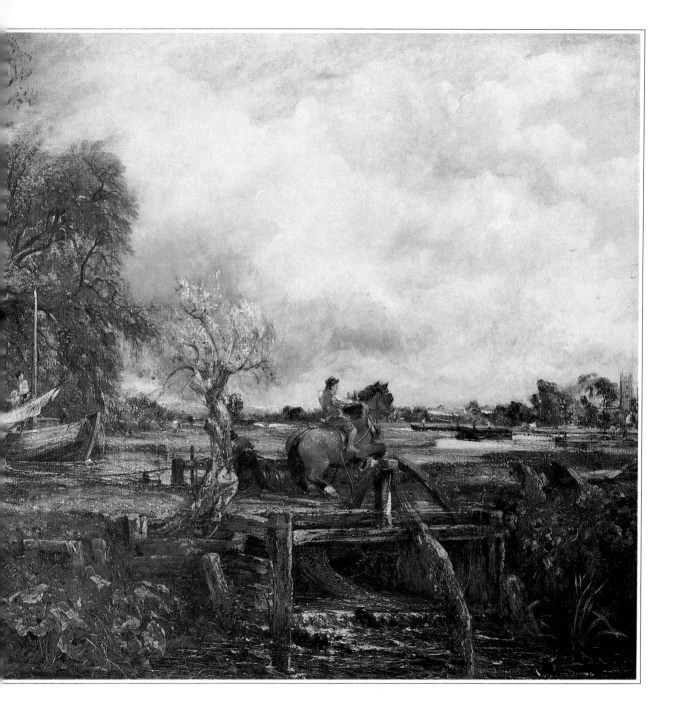

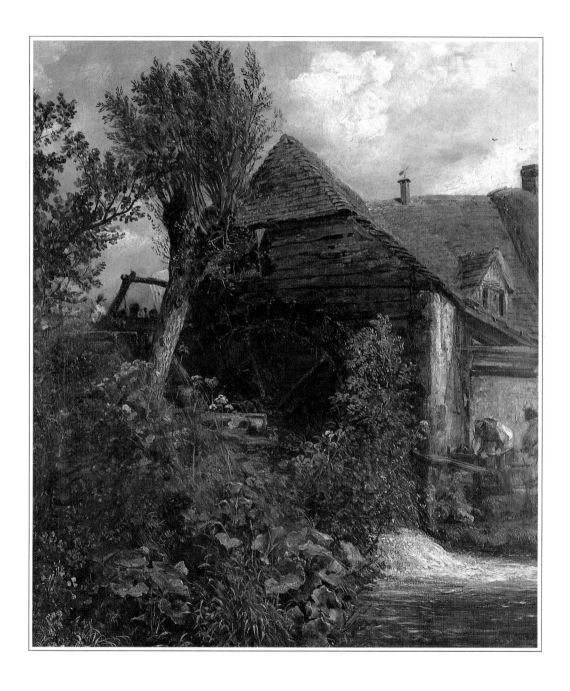

◁ **Water Mill, Gillingham, Dorset** 1826

Oil on paper

THE WATER MILL at Gillingham was a picturesque building with its large wooden mill wheel and brick house surrounded by vegetation. His visit to Gillingham was prompted by the fact that his friend Fisher had been appointed to the local church and it was Fisher who told him about the local mills. In 1823, on his second visit, Constable wrote, 'The mills are pretty and one of them wonderfully old and romantic.'

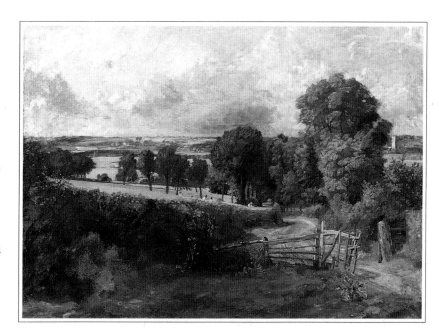

△ **The Entrance to Fen Lane** 1826

Oil on paper

FEN LANE led from East Bergholt, past the cornfield which is just visible in this picture and which Constable later used as a subject for a major painting. Constable's son, who identified this location, remembered going down the lane to Dedham grammar school as a boy. In this painting Constable keeps to the landscape without additions, except for the men seen on the distant edge of the cornfield. Later, in the *Cornfield* picture, he added animals and people as what he called 'eye salve' to please the public.

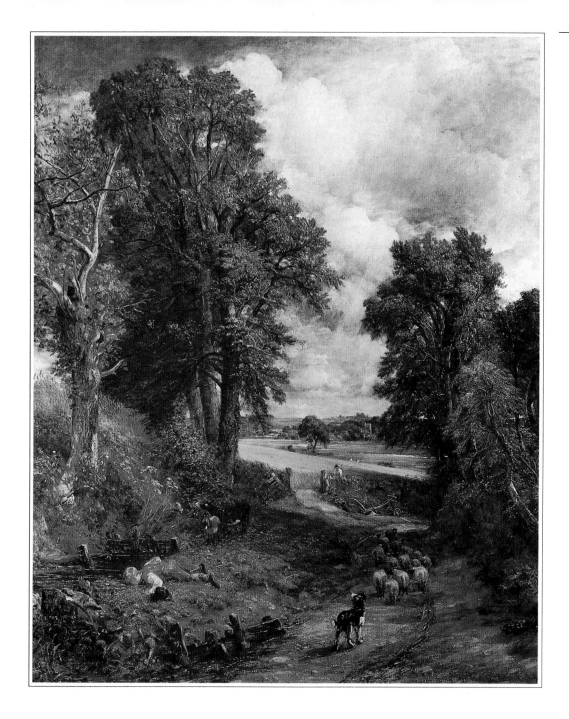

◁ **The Cornfield** 1826

Oil on paper

The centre area of
The Cornfield shows the gate
off Fen Lane leading into the
cornfield beyond. The village
across the Stour valley is
Higham, though it would not
have been visible from
Constable's viewpoint in the
lane. *The Cornfield* was the first
Constable painting to enter a
national collection and was
bought by a subscription
organized by his friends
William Purton and C.R.
Leslie, who later wrote a book
about the artist.

▽ **Dedham Vale** 1829

Oil on canvas

THIS IS CONSTABLE'S final
version of Dedham Vale,
looking over the village
towards Harwich from Gun
Hill, Langham. The sky in the
later painting has gained from
the large number of cloud
studies that Constable did at
Hampstead in the 1820s, and
has a splendour that enhances
the whole picture. Another
addition to the later painting is
the gipsy by the camp fire and
tent. The inclusion of such
human and sentimental motifs
show that Constable had
moved away from his pure
representation of nature, and
was prepared to include story-
telling touches in his work.

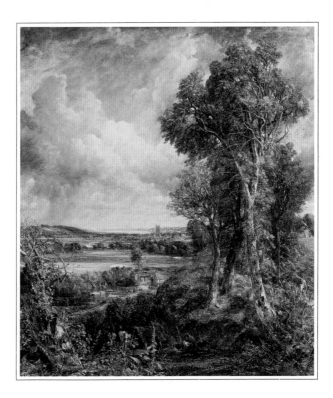

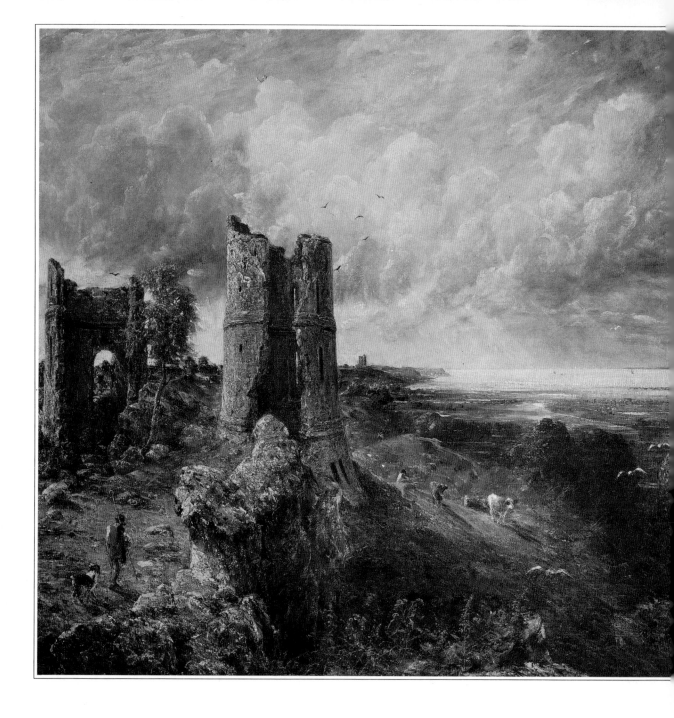

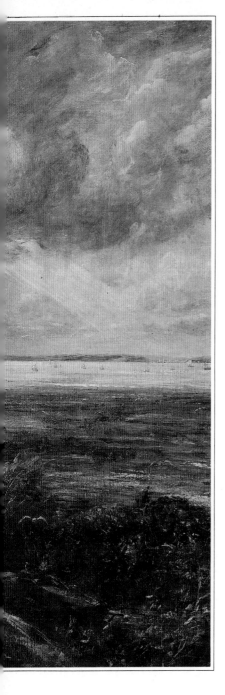

◁ **Sketch for 'Hadleigh Castle'** 1828-9

Oil on canvas

HADLEIGH CASTLE first struck Constable as a possible subject for a painting in 1814 when he visited Southend. 'I was always delighted with the melancholy grandeur of the seashore,' he told his wife Maria. The view he had in mind was from Hadleigh Castle looking out to the Nore, which was the name he gave the painting in the first instance. It took 15 years, during which period Maria died, before Constable felt happy enough about the painting to put a final version up for exhibition in 1829. This is a full-scale oil study for the final picture, sold for a mere £3. 13s. 6d. at the Executors' sale of Constable's works after his death.

Old Sarum 1829

Oil on paper

▷ *Overleaf pages 68-69*

THIS APPARENTLY rather featureless painting of the deserted mound which was all that remained of the once great town of Sarum, near Salisbury, meant a great deal to Constable. Writing in English Landscapes he said, 'The present appearance of old Sarum – wild, desolate and dreary – contrasts strongly with its former greatness. This proud and towered city once giving laws to the whole realm – for it was here our earliest parliaments were convened – can now be traced but by vast embankments and ditches, tracked only by shepherds.'

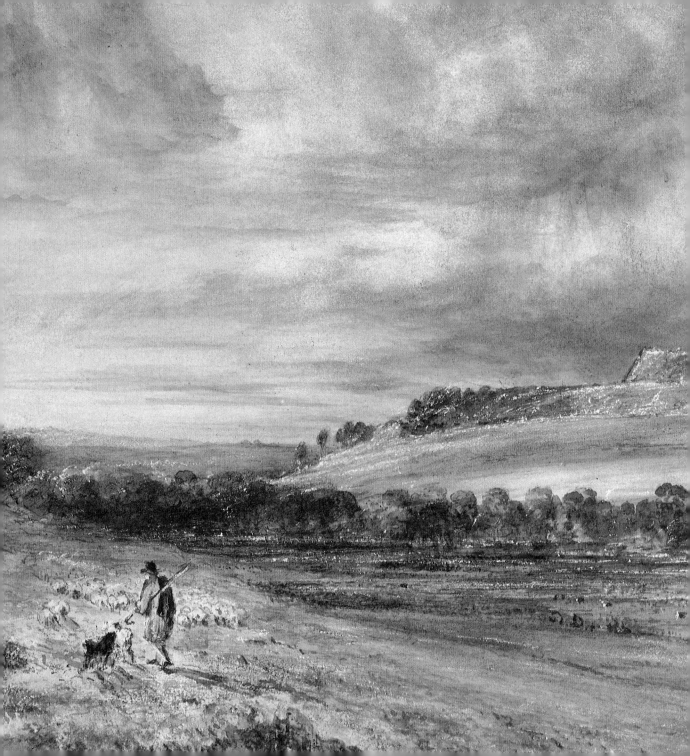

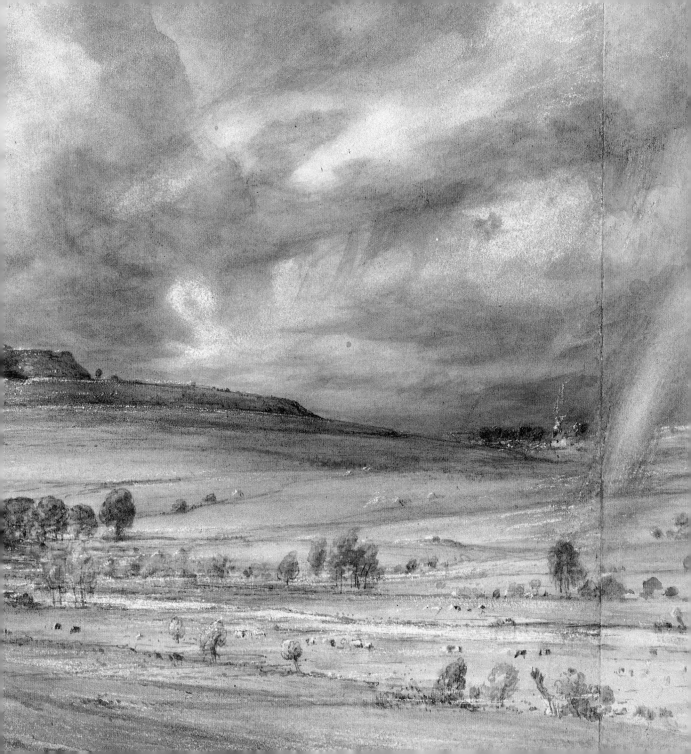

◁ **Stoke-by-Neyland** 1830

Oil on paper

TREES ALWAYS PLAYED an important part in Constable's studies of nature, not as decorative elements, as in classical paintings, but as living organisms which were part of the earth they sprang from. In his finished pictures Constable reproduced the detailed foliage effect that the public liked, but underneath the feathery surface there was always a solid foundation expressing the solidity and matter of one of nature's monuments. His knowledge of the structure of trees was built up in the course of making hundreds of drawings, sketches and studies, such as this one.

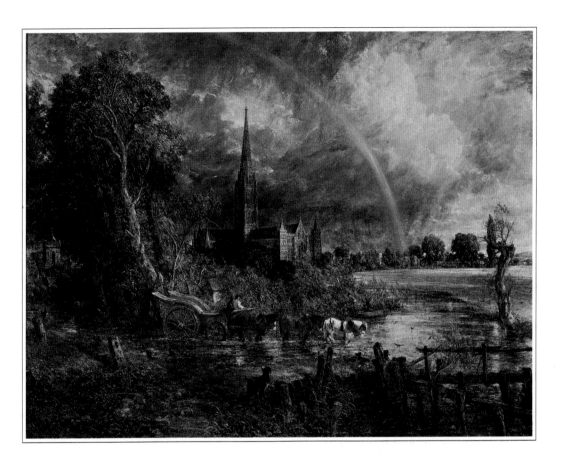

△ **Salisbury Cathedral from the Meadows**

Oil on canvas

IN NUMEROUS later pictures Constable included a rainbow in his skies, partly to give more dramatic interest to his landscapes in the manner of his contemporary Turner, but also because he had come to feel an especial emotional pull towards rainbows. 'Nature . . . exhibits no feature more lovely nor any that awakens a more soothing reflection than the Rainbow, "mild arch of promise",' he wrote in his published collection of prints, *English Landscapes*.

▽ **View on the Stour** 1831-6

Sepia wash on paper

THE RELATIONSHIP between the light and dark areas of a picture were important to Constable as the means by which the 'feeling' of a painting could be transmitted instantly to a viewer. Never satisfied in his endless search for ways to express his view of nature, Constable made endless sketches and drawings. Towards the end of his life, he took to using sepia ink to put down the mass and weight of scenes he wanted to remember. This drawing was made on a piece of letter paper.

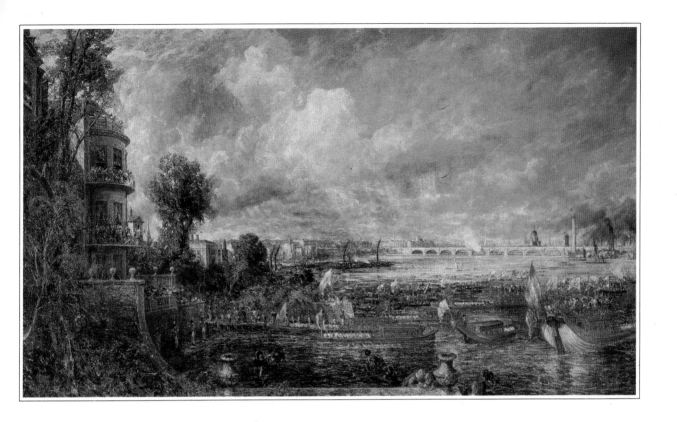

△ **Whitehall Stairs, June 18th, 1817 (The Opening of Waterloo Bridge)** 1832

Oil on canvas

THE OPENING of Waterloo Bridge by the Prince Regent on the second anniversary of the Battle of Waterloo in 1817 was a major event in Britain. It marked the end of the wars against Napoleon and the establishment of Britain as the leading power in Europe. Constable did many sketches of the ceremony and the bridge itself, and began thinking of a major painting in 1819. It was years, however, before he was able to complete it. When, in 1832, he was asked by his engraver David Lucas how the painting was getting on Constable replied that he was 'Dashing away at the great London painting and why not? I may as well produce this abortion as any other.' When it was finally shown at the Royal Academy in 1832 Turner found one of his own low-key seascapes alongside Constable's colourful canvas and, irked by the contrast, dashed in a red buoy in his own painting in order to liven it up.

▷ **Stoke Poges Church** 1833

Watercolour

THE MELANCHOLY message of Gray's *Elegy in a Country Churchyard* stirred the sensibilities of people in the age of Romanticism. Constable was commissioned to do this picture of Stoke Poges, the setting of the poem, by his friend John Martin, who wanted to make an engraving for an edition of the poem. The illustration was intended for the stanza beginning,

The breezy call of incense-
 breathing Morn,
The swallow twittering from straw-
 built shed,
The cock's shrill clarion, or the
 echoing horn,
No more shall move them from
 their lowly bed.

Constable did three versions of the church, each different from the others, and only one resembling the actual building.

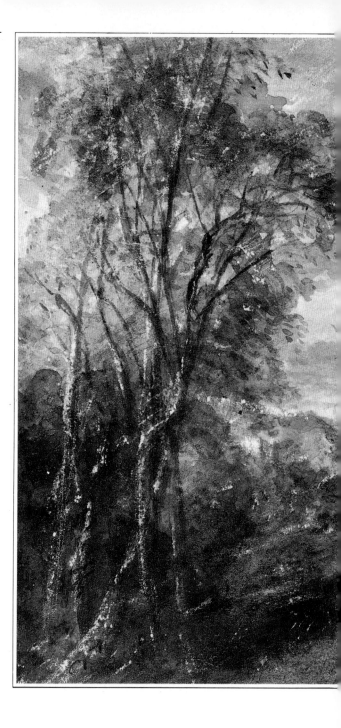

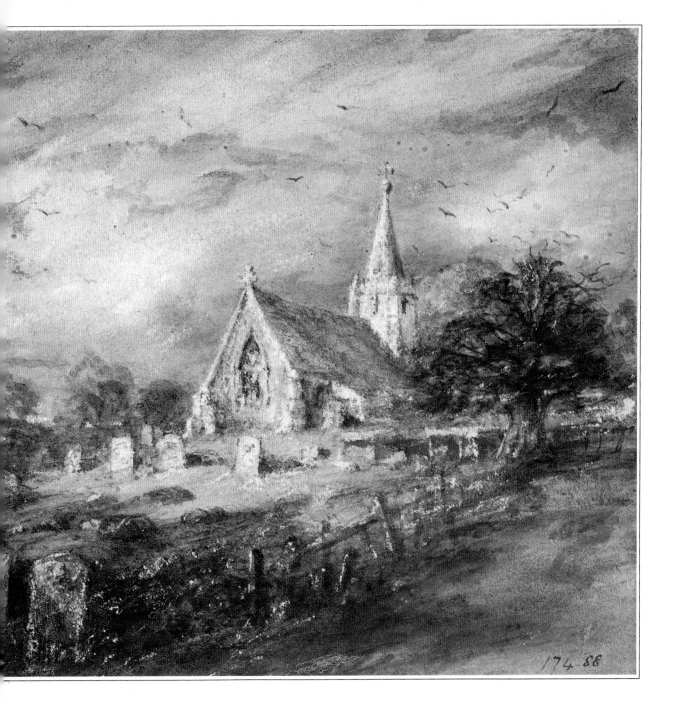

174·88

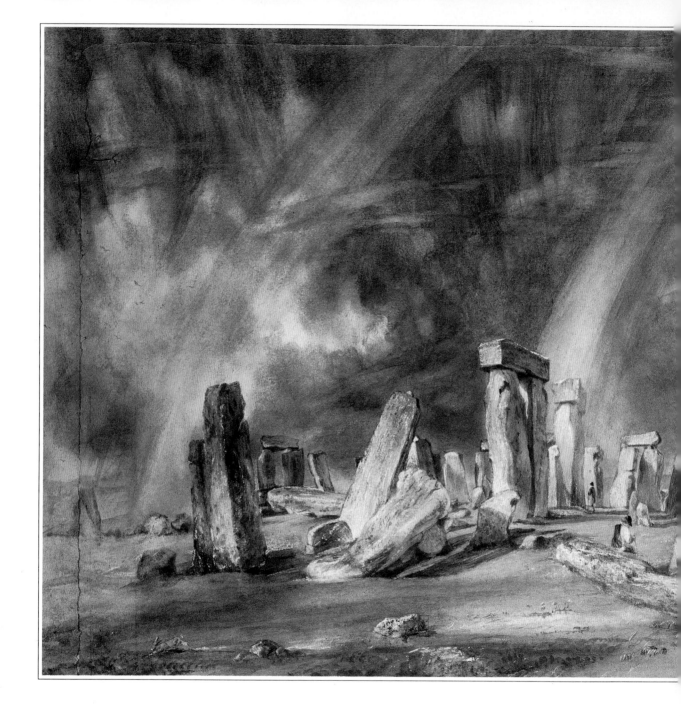

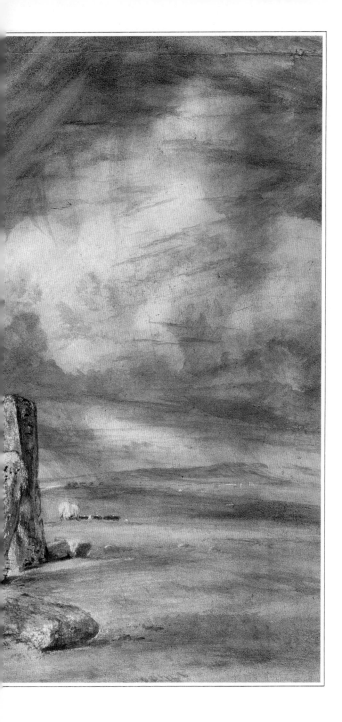

◁ **Stonehenge – the Mysterious Monument** c.1836

Watercolour

THE MOUNT of this watercolour, exhibited at the Royal Academy in 1836, bears the words 'The mysterious monument of Stonehenge, standing remote on a bare and boundless hill, as much unconnected with the events of past ages as it is with the uses of the present carries you back beyond all historical records into the obscurity of a totally unknown period.' Turner, painting the same scene, had his shepherd struck down by lightning, but Constable was less outrageous, contenting himself with a rainbow in the sky to denote the supernatural powers behind nature.

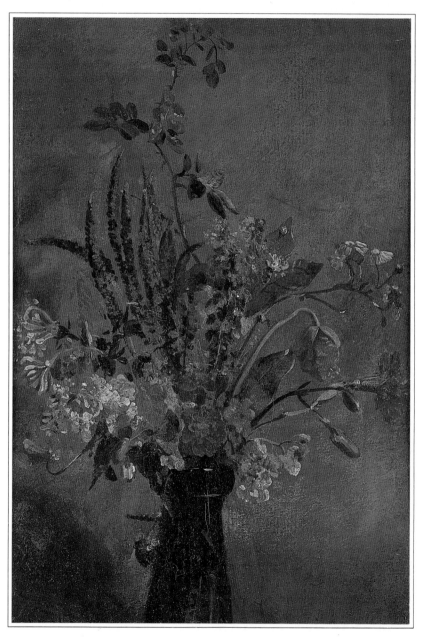

◁ **Study of Flowers**

Oil on paper

STILL LIFE AND FLOWER paintings were not subjects that attracted Constable, perhaps because he preferred to see the fauna and flora in their natural setting. From time to time, he made studies of foliage and plants for the details of his larger paintings such as *The Cornfield,* where he took great pains to make the vegetation along Fen Lane appropriate to the harvest season. These studies were a thread that ran throughout his painting career and remained as notes that were rarely turned into paintings as this one was.

ACKNOWLEDGEMENTS

The Publisher would like to thank the following for their kind permission to reproduce the paintings in this book:

Bridgeman Art Library, London /Agnew and Sons 33; /**British Museum, London** 52-53; /**Christie's, London** 23, 26, 34, 42-43, 70; /**Ipswich Borough Council** 22; /**Ipswich Museum, Suffolk** 28-29, 30-31; /**National Gallery, London** 46-47, 64; /**National Gallery of Scotland, Edinburgh** 65, /**Phillips The International Fine Art Auctioneers** 63; /**Private Collection** 50, 71, 73; /**Royal Academy of Art, London** 44-45, 58-59, 60-61; /**Royal Holloway and Bedford New College, Surrey** 48; /**Spink and Son Ltd., London** 40-41; /**The Tate Gallery, London** 27, 32, 57, 66-67; /**By Courtesy of the Board of Trustees of the V & A, London** 8, 9, 10, 10-11, 12-13, 14-15, 16, 17, 19, 20-21, 24-25, 35, 36-37, 39, 49, 51, 54-55, 56, 62, 68-69, 72, 74-75, 76-77, 78.